The Be Pembroke Jokes

TOWN AND COUNTRY CHARACTERS

A Place of Moderate Pretensions

An American visitor was having a few drinks in the bar of the Warpool Court Hotel in St David's. He turned to old Tommy James, who was minding his own business near the fireplace, and said "Say, mister, do you know that three American presidents have been born in my home town of Philadelphia?"

"By damn, there's nice for you," said Tommy.

"Any big men been born in this here town?" asked the American.

Tommy thought for a very long time, and then said "Not entirely sure, to tell the truth. But so far as I can tell, from talkin' to them as what lives in these parts, when people gets born in St David's they tends, for the most part, to be small babies."

Not Much Chance

A young man called in at a well-known kennels in Pembroke and asked the proprietor whether he had any white dogs. "We have all sorts of white dogs," said the proprietor. "Which breed would you be wantin'?"

"Well," replied the young man with a perplexed look on his face. "I'm not rightly sure. I knows what it looks like, but not the name. It is about two foot tall, like a sort of greyhound but with shorter legs, and like a sort of bulldog but with a longer nose. Then it has a droopy tail and ears

that sticks up a bit. The coat is sort of shiny an' a bit more curly than a sheepdog's coat. An' it runs like the wind an' sort of yaps instead of barkin'. Do you by any chance keep any such dogs?"

"No I do not," replied the dealer emphatically. "Very seldom it is that I gets any dogs like the one you are describin', but when I gets 'em I drowns 'em."

Perfectly Simple

A holidaymaker from Tunbridge Wells was walking up on the Presely Hills one fine day with his family in tow. The little group came across an old shepherd who was lying on his back looking at the clouds. They struck up a conversation, and the holidaymaker remarked upon the large numbers of great rocks that were lying around in the landscape. "Quite amazing!" he said. "There is nothing like this around Tunbridge Wells."

"Quite right you are, sir," said the shepherd. "Well blessed with rocks, we are. Brought down by the mighty glaciers, they do say."

"Well, fancy that! But where is all the ice and where are the glaciers now?"

"I daresay, sir, according to them what knows, that they have gone back for more rocks."

A Most Wonderful Gadget

Myfanwy Evans of Maenclochog had just been to see her boyfriend over in Fishguard, and was returning home after a most pleasurable evening. As she drove, somewhat erratically, through Puncheston, it was her misfortune to be spotted by Constable Williams in his panda car. The constable shot after her with his blue light flashing.

He indicated for her to pull in, came over to the driver's window, and said "Now then, miss, I would like you just to blow into this little gadget which I have here."

Myfanwy obliged, and when the constable examined his little gadget a happy smile came over his face. "Duw Duw," he said. "That is quite something. You **have** had a stiff one this evening, haven't you?"

Myfanwy blushed prettily. "Quite correct you are, constable," she replied. "But there's a wonderful gadget that is, to be sure. I knew it could tell you I've had a few drinks this evening -- half a bottle of wine and six brandies, to be precise. But I never knew it could tell you what else I've been doing!"

Advance Planning

Dai Jenkins was a guest at a Silver Wedding anniversary party in Pembroke. All those years ago he had been the best man at the wedding of the happy couple, and now he was the guest of honour. No expense was spared, and the bar was full of bottles of all shapes and sizes, containing red and white wine, gin, whisky, lager, sherry, port, beer, and lots of strange spirits he had never seen before. "Duw Duw, this is some party, to be sure!" said Dai, and proceeded to enjoy himself mightily.

The evening was hardly half spent when, much to the surprise of his fellow guests, Dai got to his feet and did the rounds of all those present, bidding each of them an emotional and fond farewell. The host was greatly concerned, and hurried over to Dai's side. "Now then, Dai," he said, "Surely you aren't off home yet, with the evenin' only just gettin' under way?"

"Why no, boy," replied Dai. "I'm not off home for a long while yet. Just being polite, I am. I thought I'd better just say goodnight to all of thee while I still knows thee all!"

Amusements Galore

A young man from Cardiff arrived in Cenarth for a holiday with an elderly relative. After a few hours he was already bored, and went down to the bridge to see if he could discover where the action was. He met a local fisherman there, who was leaning over the bridge and looking into the swirling water below.

"Can you please tell me where the cinema is?" he asked.

"No cinema," said the fisherman.

"Then where do they have the local disco? Or the local night-club or dance hall?"

"You must be joking, indeed. No such things in Cenarth."

"Do you mean to say there are no amusements at all in this wretched place?" groaned the disappointed visitor.

The local man brightened up immediately. "Oh yes indeed," he said. "Last year Dafydd Dafis fell out of his coracle, he did. The council meets on the first Monday of each month, and if it's action you are after the Cardigan bus comes in at four o'clock every market day, weather permitting."

Small Accident in Saundersfoot

Morgan Liquid Refreshment lived in Saundersfoot, and was so named because of his habit of consuming too much, too often. One day an Englishman moved to the village, and discovered that he and Morgan shared a taste for fine Scotch whisky. He invited Morgan round for a glass or two, and when it was time for Morgan to go the Englishman said: "Here, Morgan, there is a spot of the Scotch left in the bottle. You have it with my compliments; I'll put it here in your coat pocket, so that you can enjoy another little drink when you get home."

Morgan was almost moved to tears by this gesture. He thanked the kind Englishman, put on his coat and took his leave.

Now it happened that there was a hard frost that night. On the way home Morgan, somewhat unsteady on his feet, slipped on the pavement and fell to the ground with an almighty crash. He was knocked out for a minute or two; and when he came to he could feel something liquid running down his leg. "Good Heavens and God Almighty!" he exclaimed. "I hope to God it's blood."

Beautiful English

This is a tale from the Primary School of Herbrandston, not far from Milford Haven. One day the teacher was conducting an English lesson. In the course of it he asked the class to write down sentences with certain phrases in them.

"Now then, children," he said. "I want you to complete some sentences in an interesting way, using phrases like "as straight as an arrow", or "as tall as a tree", or "as white as a snowflake." For example, can anybody complete this sentence?"

And he wrote onto the blackboard the words "........ as hard as a"

Immediately Billy Jenkins shot his hand up. "Please sir! Please sir!" he said. "I knows the answer!" And he delivered his written text to the front of the classroom. The teacher examined it with interest, for it read as follows: "Tommy fell down and cut his elbow. So a ran home as hard as a could."

Just a bit of Favouritism

Mary Murphy and her husband Seamus were good Catholics, and they had been living in Merlin's Bridge for many years. They had fifteen children, who all appeared to live in reasonable harmony. Many of the neighbours wondered how on earth they managed to get by on Seamus's small wages. One day a BBC reporter, who was doing a programme about large families, came to see them. He wanted to press Mary on the frictions and rivalries that must exist when so many small children were living cheek by jowl, and he asked Mary if any of the children were her particular favourites. "Oh yes indeed," replied Mary. "Some of them are my great favourites, and I'll do absolutely anything for them."

"Oh? And which ones might they be?" asked the reporter, holding the microphone out for her reply.

"The ones who are miserable, until they cheer up," said Mary. "And the ones who are sick, until they get better. And the ones who are away, until they get home."

Much The Same

In the bad old days life was tough up in the Presely Hills, and the smallholders enjoyed few luxuries in life. Will met Twm in the "Drover's Arms" in Puncheston.

"Come and have a bite to eat with me tonight," he said. "Not much - just boiled beef, spuds and carrots."

"Most generous of you, Will," replied Twm. "Happy to accept, I am. It's a funny thing, but I was goin' to have exactly the same for supper meself, barrin' the beef and the carrots."

Adequate Proof

Some years ago a visitor to Marloes called at the Post Office to collect a registered packet that had been sent to him in advance "to await arrival." The lady at the counter was very conscientious, and had recently been warned by the Postmaster General to be very strict on security matters. So she refused to accept that the visitor was really the person for whom the packet was intended. "Have you no means of identifying yourself?" she asked. "Passport, driving license, or cheque book?"

"Nothing at all," said the visitor. Then he thought for a moment and took out a photograph from his inside pocket. "But this is a photo of myself which I took in one of those machines on Paddington Station."

The lady behind the counter looked at it carefully, and then looked the visitor in the eye. "Well, sir," she said after due deliberation. "I can definitely see the likeness. Whoever you are, you are certainly not somebody else, so here is the packet you asked for."

The Workmen of Trecwn

Many of the operations undertaken at the Royal Naval Armaments Depot at Trecwn were shrouded in secrecy, and there was some doubt locally about the size of the work-force. One of the standard replies to the question "How many men work at Trecwn?" was "On a good day, about half of them."

Rumour has it that a cameraman from the Royal Navy once visited the depot with a new-fangled movie camera. He was shooting some location film from a lane along the Trecwn valley, and happened to meet an old farmer. Keen to show himself as friendly to the natives, the cameraman said: "Good afternoon, sir. I have just been taking some moving pictures of life in the armaments depot with this special camera."

"Well well, there's nice," said the old farmer. "And did you catch any of the men moving?"

"Oh, indeed I did," came the reply.

The farmer shook his head reflectively. "Science is a wonderful thing," he said slowly, and went on his way.

A Funny Name

A well-known local burglar was doing a spot of burgling in one of the more affluent suburbs of Pembroke Dock. Having affected an entry to the living room at dead of night, he prowled about, inspecting the fittings with his flashlight. Suddenly he was frightened out of his wits by a voice from the corner, which said "Jesus is watching you."

Having recovered his composure, the burglar shone his torch in the direction of the voice, and saw a parrot sitting on its perch inside a cage. "Did you say that?" he asked the parrot. "Of course I did," replied the bird. "And what's your name?" asked the burglar. "Jennifer," said the parrot.

The burglar laughed and said "Jennifer the parrot? That's really funny."

"Not half as funny as Jesus the rottweiler," said the parrot.

The View from Foelcwmcerwyn

A group of intrepid English ramblers had spent a hard day hiking along the summit ridge of Mynydd Presely and at last, around sunset, they approached Presely Top or Foelcwmcerwyn. There they encountered an old shepherd, lying on his back and watching the world go by. "Good evening!" said one of the visitors. "What a lovely day it's been. And what a view! I suppose you can see for miles and miles in all directions from here?"

"Oh yes indeed," replied the old man, still lying on his back. "On a clear day you can see as far as Narberth that way, and Llangrannog that way, and Croesgoch that way, and Marloes that way."

"Good gracious, " said another of the tourists, nudging his friends and giving them a wink. "And I suppose that when it is exceptionally clear you can see as far as London?" "Oh no problem at all, at all. Much further than London, indeed."

Now the tourists were beginning to enjoy themselves. "And probably after rain you can see as far as New York out there to the west?" "Much further than New York, indeed. Most wonderful views we have here, to be sure."

Then, as the tourists were wondering about the next stage of their little joke, the old shepherd gave a good stretch and a yawn, got up, and ambled down the track towards Rosebush. He turned round and said: "If ye don't believe me, just ye sit down by here for a couple of hours, and if the clouds will just clear a bit ye'll be able to see all the way to the moon!"

A Stranger in Town

A crowd of old boys were sitting in the bar of the "Royal Oak" enjoying a few pints and telling a few tales. They got to telling jokes, and Dicky Dumpling said "Number twenty-one." Everybody roared with laughter. Then Fred Ferry said "Number sixty-five" and the laughter reverberated round Fishguard Square. So it went on far into the night.

At last Owen Opera said "Number forty-three", but everybody groaned and complained that it was so old that it wasn't funny any longer. Then they noticed that there was a stranger in the corner, who was laughing so much that he spilt his beer all over the table. His laughter was quite uncontrollable, but at last the locals bought him a new pint and managed to calm him down. Then they asked him what was so funny. "Dammo, it was that Number forty-three!" he said. "Good old joke. But what really got me going was the way that he told it."

Living Together

Two old brothers lived together in a little farmhouse near Mynachlogddu. One of them met a friend at Crymych mart, and was clearly in a bad mood. On being asked what was the matter, he replied: "That bloody brother of mine makes life unbearable at times, he does. He keeps all them dogs and cats in the bedroom, and sheep in the kitchen and goats in the dinin' room. It smells terrible, and they do say that such things is unhealthy too."

"Well, why don't you open the windows?" asked the friend.

"What?" exclaimed the old brother. "And let all my beautiful pigeons escape?"

A Stroke of Genius

Einstein Edwards was, by Marloes standards, a very smart young fellow, and the locals thought he would go far. Then somebody recommended him for an appearance on "Brain of Britain" on the BBC radio, and the whole village was delighted when he was accepted. On the great day everybody in Marloes tuned in to Radio Four, and there was great excitement when Einstein's turn came. "Now then Mr Edwards," said Robert Robinson. "What is the equinox?"

"Ah yes," said Einstein. "I thinks I knows the answer. This is a very scientific question, isn't it?"

"You could say that," said Robert Robinson.

"This is all to do with this trendy stuff about genetic engineering," said Einstein. "Therefore I has to conclude that the equinox is the strange lookin' beast produced by the crossin' of a horse with a cow."

A Considered Response

It was a cold and frosty Christmas morning, and Micky Reynish thought he heard a small voice at his front door, saying over and again "Happy Christmas, mister! Happy Christmas, mister!" So Micky went to the door and opened it. He couldn't see anybody at all, but then the little voice said, from down on the doorstep: "Please for a few morsels for a hungry orphan?" He looked down, and there was this little snail not far from his foot. Micky didn't like snails, so he shouted: "Don't you be cheeky with me! Bugger off!" And with that he kicked the snail right down to the bottom of the garden path.

Micky closed the door, went in to have his Christmas dinner, and then thought nothing more of it.

A year later, on the next Christmas morning, Micky thought he heard a little voice at his front door saying "Hello mister! Hello mister!" So he went and opened the door, and when he looked down there was this little snail with a big plaster on his shell and saying in an aggrieved tone of voice: "Whatcha do that for?".

Finding a Gardener

The master of a big house near Hayscastle found himself a charming young wife. The new mistress had much to learn about the running of the household, but she recognized her own inexperience and was keen to take

the advice of others. One of her tasks was to find a new gardener to look after the grounds, and she advertised the post in the "West Wales Guardian". There were two applicants for the job, and by coincidence they both turned up for interview at the same time.

The young mistress talked to Harry first, but he was a shy fellow who did not make a good impression. Then she talked to Jenkin, who was a confident and fluent talker. The mistress was about to offer the job to Jenkin when she spied the old housekeeper in the porch behind the men. She was gesturing frantically towards Harry, making it perfectly clear as to her preference. The mistress decided to take the old lady's advice, and gave the job to Harry. Afterwards she asked the housekeeper why she seemed so certain that the one applicant was so much better than the other.

"Well, ma'am," she replied. "I has learnt meself over the years that when lookin' for a gardener you looks at his corduroys. Harry has his patches on the knees, which is where you likes to see 'em. But as for that Jenkin - he have got his patches on his bum!"

Generally Speaking

A visitor to the village of Manorbier was having a walk across the valley, and arrived at last in the churchyard. There he found the local grave-digger hard at work on a new grave, ready for a burial to take place on the following day. Keen to strike up a conversation, the visitor said. "Good afternoon, sir. What a very pleasant day it is. Tell me, do people round here die very often?"

There was a long silence, and then the sexton replied. "Well sir, I cannot say what happens over Lydstep way, and I hears that there is funny goins on over by Jameston and Hodgeston, but generally speakin', in Manorbier itself, so far as I can make out, they tends to die just the once."

A Wise Precaution

Toby Thomas from Solva went to sea, like many others from his village. What's more, he could write, and the officer on board his first ship was greatly impressed when, in signing a document, Toby signed the first part of his name with his left hand and the second part with his right. "Very impressive," said the officer. "We don't get many ambidextrous people on the crew of this ship."

Toby did not know many long words, but he assumed this was some sort of a compliment. "No problem, sire," he replied. "When I was a boy me father - God rest his soul, for he drowned in the Bay of Biscay - always said to me: Toby, you just learn to cut your finger-nails with your left hand, for some day you might lose your right."

Getting Stronger by the Day

A visitor to Fishguard heard that old Sid Roberts had recently celebrated his hundredth birthday. Never having met a centenarian before, he paid a visit in order to give his respects. In the course of the conversation the visitor congratulated Sid on his hail and hearty appearance, and added as a joke "But I presume you do not expect to see out another hundred years?" The old man thought for a while.

"Well now, you never can tell," he replied. "For sure I'm a good deal stronger now than when I started with the first hundred."

The Art of Energy Conservation

A farm labourer from Wiston was seeking work at the Portfield hiring fair. He got into conversation with a Rudbaxton farmer, and assured him that never, in any circumstances, did he get tired.

"Aha!" said the farmer. "There are not many of your kind about. You are just the sort of man I want. You have got yourself a job."

A couple of days later, whilst riding along a leafy lane on his land, the farmer came across the new farmhand, who was supposed to be hedge-trimming. The boss was surprised to see him flat out on his back in the shade of a great oak tree, dozing contentedly as the air was filled with bird-song. "What's this?" cried the farmer. "I thought you said you never got tired?"

"Well now," replied the labourer, rubbing his eyes. "No more I don't. But I pretty soon would, master, if I didn't have a bit of a rest now and again."

Ask a Stupid Question....

Once upon a time an English visitor to Stackpole Court was walking through the woodland on the estate when he came across a local peasant standing alongside a decayed tree with a crosscut saw in his hand.

"And what are you intending to do with that saw, my good man?" asked the visitor.

"I'm gwain to cut'n down, sir," replied the peasant.

"And then what are you going to do?"

"That's a hard question, sir," said the local, "but after thinkin' about it I reckons I'd better cut'n up."

Georgie's Trip to Market

In the old days it used to be said (by people who should have known better) that the people of Marloes were a bit slow on the up-take. They were referred to all over Pembrokeshire as "Marloes gulls", maybe because gull's eggs were a part of their diet. There are many famous stories about Marloes folk, and this is one of them.

Billy was out one Friday morning in his garden, dressed up in his oilskins since it was pouring with rain. He was watering his roses with a watering-can. As he worked he saw his friend Georgie going past, with a wheelbarrow half-full of onions. Later on in the day, just as it was getting dark, he saw Georgie coming back again, still pushing his wheelbarrow with the onions in it.

"Where'st tha bin?" shouted Billy.

"It's Harfat market tomorrow," replied Georgie. "Tis a devil of a long way to go with all me onions to sell, so I thought to meself I'd go halfway today, so as to make the journey that much quicker tomorrow."

"So why hast tha come back again after goin' all that way?"

"I has to get a good night's rest in me own bed so as to have the strength for the rest of the journey. An' can't tha see, tha daft bugger, that me barra is only half-full of onions? I had to come back whatever, to fetch the other half."

The Wrong Jones

At the height of the Cold War a Russian spy was parachuted at dead of night into the wild country near Mynachlogddu, with the purpose of gathering information about the US Naval Facility at Brawdy. He had instructions to contact Mr Jones of Maenclochog. After fighting his way

across moorlands and through bogs he arrived in the village early in the morning and went to the Post Office, where he ascertained that a Mr Jones lived just up the road. He knocked on the appropriate door, which was duly opened by a gentleman. "Are you Mr Jones?" asked the spy. "Yes, I am," replied the man.

The spy looked furtively over his shoulder and said: "The tulips are blooming well today." "I beg your pardon?" "The tulips are blooming well today."

At last Mr Jones got the message. "My dear fellow, you have come to the wrong house," he said. "I am Jones Pentagon. You want Jones Kremlin, who lives at number fifteen.

Unsound Advice

A holidaymaker was driving along a country road one warm summer afternoon near Wiseman's Bridge when his engine stalled. He lifted the bonnet and pottered about for a while with the electrical connections. Still the car would not start. At last, frustrated and angry, the motorist sat down in the hedge and waited for another motorist to come along who might be able to give him some help.

A few minutes later a herd of cows came down the road, heading towards a nearby farm for the evening milking. Several of the cows ambled past, and then the motorist was greatly surprised when one of them looked under the raised bonnet of the car and said "From what I can see, your problem is probably a blocked carburettor."

The man was greatly surprised at this. At last, when all the cows had gone past, the farmer came along with a long stick in his hand and his sheepdog at his heel. "I say," said the man. "One of your cows just looked under the bonnet of my car and said I had a blocked carburettor!"

"Was it a big white one with a speckled face and a black rump?" asked the farmer.

"Yes Yes, that was the one," said the holidaymaker.

"That would be Buttercup then," replied the farmer. "If I was you, I wouldn't listen to her. She don't know nothin' about carburettors."

Billy's Sad Task

This is another tale about the good folks of Marloes. Old Josh Edwards was walking along the Martin's Haven lane one day when he noticed his friend Billy hard at work in a field. On closer examination he saw that

Billy was digging a deep hole in the ground, and that there were four other holes nearby, surrounded by great piles of earth.

Mornin' Billy," said Josh. "Big job tha's doin' there. What's tha diggin' all them holes for?"

"Mornin' Josh," replied Billy, a bit short of breath. "Bad business it is. Me ol' sheepdog have died, an' I has to bury'n. But I'm havin' terrible trouble with all this diggin'. Them two holes over by there was too big an' these two holes over by here was too small to fit the ol' dog into. I hopes to God I gets it right this time, or I'll be here all night."

A Helping Hand

An old farmer from Camrose was going about his business when he noticed that some holidaymakers had stopped their car in the lane near his orchard. The family of four had all climbed over the hedge, and there they were, collecting up fallen fruit from the grass beneath the heavily-laden trees.

Some time later the holidaymakers returned to their vehicle, to find the farmer leaning against the hedge chewing on a piece of straw. "Oh hallo," said the father. "We helped ourselves to some of the fallen fruit in your orchard, which was only going to go rotten if it was left there any longer. We hope you don't mind."

"Oh, that's all right," replied the farmer. "While you were away I helped myself to some of the tools from the back of your car, which looked as if they were just lying there getting a bit rusty ."

The Man for the Job

A wealthy farmer from Maenclochog had a flock of a thousand sheep up on the Presely Hills, and when he began to feel his age he decided that he needed to hire a shepherd to look after them. He advertised in the "Western Telegraph" and had three applicants for the job. One of them was a Pembrokeshire man from Tenby, another was a Carmarthen man from Kidwelly, and the third was a Cardi from Tregaron.

He couldn't decide which of the three to hire, so he sent all three up the mountain to see how they got on. On the second day the Pembrokeshire man came down off the mountain, complaining that he couldn't stand the smell. On the fourth day the Carmarthen man came down, complaining that he couldn't stand the smell either. On the sixth day, the thousand sheep came down.

The New Maid

Mrs Edwards from the big house in Martletwy had got a new maid. The girl was somewhat slow on the uptake, and her work was distinctly slovenly. Having warned her many times about jobs undone or poorly done, Mrs Edwards said she would give her one last chance to show that she was worthy of her post.

Next morning Annie was cleaning the parlour, having already dealt with the dining-room to her satisfaction. Mrs Edwards made a quick check and shouted: "Annie! Just come into the dining-room for a moment. I want to show you something." Annie obediently hurried in from the parlour.

"Now look at this," continued the lady of the house angrily. "Just watch me. When I move my finger like this I can write my name in the dust on the dining table. So what do you have to say about that?"

"There's wonderful, Madam," replied Annie with an appreciative smile. "It jest goes to show what a bit o' schoolin' can do for you."

Getting It Over With

An old farmer from up in the hills near Tufton had to go to Withybush Hospital for an operation. As soon as he arrived he was undressed by two young nurses. He protested violently, but after a struggle they got the better of him. He was given a good bath and then wrapped up in nice warm towels.

As he left the bathroom he turned to one of the nurses and said: "Well, bach, there's glad I am that that's over. It wasn't so bad after all. To tell you the truth I've been dreading that operation these five years or more."

Too Much to Do

Luke Mathias and his wife farmed a hundred acres near Johnston. One day they decided that they needed a spot of culture, so they bough some tickets for a play at the Torch Theatre in Milford. On the appointed evening, off they went in a state of high excitement, leaving a babysitter in charge of the children.

An hour later they were back home again. The babysitter was greatly surprised, and asked if the play had been so bad that they had left early.

"No no," said Luke. "By damn it was a fine play -- very exciting indeed. But then there was this interval, and we read in the programme "Act Two, two days later". All these people were standin' around with time on their hands, havin' drinks and peanuts, but we knew that if we stayed we would have to pay you overtime and miss tomorrow's milkin' and Harfat mart. So we decided to come home."

Tenby's Wonderful Machine

Tenby has a reputation for being in the forefront of modern technology when it comes to the amusement of tourists. Not long ago Tony Eldorado, one of the enterprising businessmen of the town, installed a machine in his amusement arcade which would give the correct answer to any question after you put 50p in the slot.

On the great day for the inauguration of the machine Tony invited all the civic dignitaries of the town around for a demonstration. "Ladies and gentlemen," he said proudly. "This machine is the latest thing from Japan. It will attract thousands of visitors and transform the economy of this seaside town, and I am proud to be the person responsible. Now then, let me ask the Chairman of the Council to give the first demonstration."

So Councillor Willy Williams rattled his chain of office, smiled happily, put 50p in the slot, and asked a simple question. "Where is my father now?" he asked. "Your father is fishing from the harbour wall in Saundersfoot," replied the machine. The civic dignitaries were not impressed, because they thought, like the Chairman of the Council, that his father was dead.

So Willy rephrased his question: "Where is my mother's husband?"

Back came the reply: "Your mother's husband is buried in Pembroke Dock, but your father is still fishing from the harbour wall in Saundersfoot."

On Thin Ice

Gertie and Dafydd Rees lived in Newport. One bright and frosty morning in January an elegant visitor knocked at their front door. Gertie opened up, and the visitor said "Good morning, madam! Is your husband at home?"

"Might I ask where I can find him?"

"Down on the estuary he is, by the Iron Bridge."

So the visitor said "Ah yes! I know where that is. Might I ask what he is doing down there?"

"Well," replied Gertie, "if the ice is as thin as he thinks it is, he's gone skating. If it's as thin as I think it is, he's gone swimming."

LOCAL POLITICS

Enough to Get On With

One day a delegation called on Freddie Jenkins at his home in Tenby and asked him if he would like to stand in the County Council elections. He was very reluctant, but the members of the delegation pressed him hard, making points about duty and responsibility, and the need for a good party man to represent the local area as an independent candidate. However, Freddie was adamant that he had neither the time nor the inclination to become a county councillor. He concluded the interview by saying: "Gentlemen, I thanks thee from the bottom of me heart for the great honour of askin' me to stand agin the sittin' councillor Tommy Nicholas in this 'ere election. But I has to say, with great reluctance, that I ain't in no position just now to neither stand in the vote nor sit on the council, since I finds meself constantly on the run. I has a wife, a teenage daughter, a mortgage, a third-hand car, and two bloody poodles, an' I reckons that is quite enough trouble for one man."

Bidding for the Job

When the sea defences at Newport had to be strengthened, the County Council had to put the job out to competitive tender. They invited bids from Ifan Ifans Ltd of Carmarthen, Twm Tomos Ltd of Cardigan, and Willy Williams Ltd of Tenby.

The bids duly arrived in sealed envelopes, and were opened at 12 noon on the appointed day, in the presence of a team of senior officers. The Head of Roads, Bridges, Pavements and Toilets announced that the Carmarthen firm had quoted £2,000 for the job, the Cardigan firm £4,000, and the Tenby firm £6,000. Naturally enough, the job was given to the Tenby firm on the grounds that this would represent best value for money.

Afterwards the Chairman of the Council was having a quiet drink with Willy Williams. "By damn, Willy," he said, "that was one hell of a bid you put in. Two thousand quid more than the Cardigan bid and three times as much as the Carmarthen one. We had a bit of a job to justify giving you the job, and the Treasurer was not a happy chappy. Where the hell did you get that price from?"

"Oh, same old calculation as usual," replied Willy. "Two thousand

quid for thee, two thousand quid for me, and I'll pay that daft bugger from Carmarthen two thousand quid to do the job."

Searching for the Lord

Before his elevation to the peerage, Lord Gordon Parry lived for many years in the little town of Neyland, on the north shore of Milford Haven. He was very active in local politics, and stood in a number of parliamentary elections as a Labour candidate. He worked in Sir Thomas Picton School in Haverfordwest, and was - and still is - a very popular figure in the public life of the county.

Gordon was still living in his unpretentious terrace house in Neyland at the time of his elevation, and it took a little time for everybody to get used to his new title. According to legend, a few days after the announcement, there was an evangelical crusade going on in Neyland. A band of enthusiastic amateur evangelists had been trained in doorstep crusading techniques, and off they went on their heavenly mission.

One enthusiastic young man had been briefed to knock on all the doors in the street where Lord and Lady Parry lived, in order to spread the Gospel. When he knocked on the door in question, it was opened by Lady Parry, who did not happen to be wearing her regalia at the time. Indeed, she looked, to all intents and purposes, like a perfectly ordinary housewife. The young man offered up a silent prayer, took a deep breath, and with one hand on his heart and the other on his Bible, he asked in his best trembling evangelical voice: "Madam, is the Lord in your house?"

Quick as a flash, Lady Parry replied "Not just now. He's out the back digging up some spuds. Hang on and I'll go and fetch him!"

Qualified for the Job

In the good old days when Pembrokeshire County Council ran the schools of the county, the Chairman of the Education Committee was one Cllr Emlyn Jones. He was so illiterate that he couldn't read even the clearest handwriting. At one committee meeting a new clerk came in and delivered a letter relating to an important agenda item, and he noticed that, after opening it, Cllr Jones was holding it upside down and scanning it intently. "Excuse me, Alderman Jones," said the clerk meekly, "but if I may say so you are holding the letter the wrong way up." This caused great embarrassment among the committee members, but the Chairman was equal to the occasion.

"Now look ye here, young man," he said haughtily, "do ye think I could have got up to this here elevated position as Chairman of the Educatin' Committee if I couldn't read a letter upside down, or come to that, with any side up whatsoever?"

A Perfect Title

According to legend, Gwilym Lloyd George was proving to be a bit of a thorn in the side of the Tory Party. The Prime Minister, Harold MacMillan, thought it would be a good idea to put him out of harm's way in the House of Lords. So one day MacMillan suggested to him that he might like to make the move from the Commons. Gwilym was not too keen on the idea since he rather liked causing trouble in the House of Commons, but he promised that he would think about it.

Some time later MacMillan approached him again and put further pressure on him, and after due deliberation Gwilym said "All right, Prime Minister, I will make the move if you think it is in the best interests of the party."

"Splendid, splendid!" said the Prime Minister. "What would you like to take as your title? Choose something appropriate from your home area."

"As it happens I am very fond of Pembrokeshire," replied Gwilym. "Would it be acceptable if I give some thought to choosing a name from the very lovely area around Saundersfoot and Tenby?" The Prime Minister was delighted, and Gwilym went away to give the matter further thought.

Next time the two men met in the corridors of power Gwilym said "Prime Minister, I have made up my mind which name to use in my title."

"Splendid, splendid," said MacMillan. "Tell me what it is, and I will set the wheels in motion."

"I have decided," said Gwilym, "on a beautiful name. In future, I would like to to be known as Lord Stepaside."

The True Blue MP

Shortly after Nicholas Bennett was elected as MP for Pembrokeshire, a deputation from Milford Haven visited him in the House of Commons. He was showing them round the Library when one of the deputation said to him "Now then, young man. I has to say to thee that the locals is not amused. Nobody knows what th'art doin' here in Westminster on behalf o' local interests. We sees nothin' in "The Telegraph" about no speeches nor nothin'. What art tha gettin' up to all the time?"

The Member for Pembroke went to a library shelf and took down a heavy tome. Then he said; "You need not worry, Mr Thomas. I take a full and active life in the Mother of Parliaments. Committees, meetings, debates, all day and all night. You see this heavy book I have in my hand? It is called Hansard, and it records all the proceedings of the House. My activities are fully recorded here. You see this page, for example? The Prime Minister's speech of March 23rd. Here, in the middle of the transcript, you see in brackets the word "Murmurs." Well, I was the man who murmured."

The New Tory Voter

Old Tommy Jenkins had been a Labour voter all his life, and a faithful member of the Trade Union into the bargain. There was a parliamentary election in the offing, and the party faithful sorely missed Tommy's help on the campaign trail. But he was seriously ill, and the word went about that he was going downhill fast.

On the day before the election a rumour reached Party HQ that old Tommy had joined the Tory Party. This was greeted with disbelief, for nobody could believe that Tommy had undergone a deathbed conversion after devoting most of his life to the Labour cause. Tommy's pals decided that severe damage was likely to be done to party morale unless this rumour could be stopped; and so a delegation was sent to visit him and find out the truth.

On arrival at Tommy's house later that evening the friends were ushered upstairs to find the old man looking very ill indeed. After a while they asked him if it was true that he had joined the Tory Party, and they were dismayed when he told them that it was indeed true. "But this is how I sees it, boys," said Tommy. "I knows my time has come, and I won't be seein' the light of day tomorrow. So there will be no vote from me in this 'ere election. But we needs every vote we can get, so I thought it was better for them buggers to lose a vote than for us to lose one of ours!"

Duly impressed by this impeccable logic, the friends departed, leaving Tommy on his death-bed with a saintly smile upon his face.

Most Offended

The Dyfed-Powys Police were having a crackdown on the heavy drinkers of the country districts, and having heard that a certain pub in the hills near Maenclochog was "open all hours" the superintendent sent two officers in a panda car off to investigate. Having ascertained that drinking was in full swing round about midnight, the officers observed the pub from a safe distance and waited for the customers to emerge.

Round about 1 am Cllr Davy Davies emerged, none too steady on his feet, and got into his car. Then he drove off down the lane. The panda car set off in hot pursuit and what with all the flashing blue lights and sirens Cllr Davies thought it best to stop. The officer came to the window of the car.

"Good morning, Councillor Davies," said the policeman. "May I ask you whether you have been drinking prior to driving off in your car just now?"

"Yes indeed," replied the good councillor. "I had three double whiskies before lunch, three pints of beer this afternoon, and this evening in the pub I had two very nice brandies, six pints of beer, and a vodka or two to finish."

"Oh dear," said the officer. "That sounds like quite a lot of alcohol. I'm afraid I'll have to ask you to take the breathalyser test by blowing into this little tube."

At this Davy got very angry indeed. "My dear fellow," he said. "Do you realise who I am? Councillor Davy Davies is my name. A councillor for thirty years, chairman of the Housing Committee, a respectable citizen and a deacon of Gethsemane for twenty years! I shall have something to say to your superintendent, that's for sure. Most offended I am, that you don't believe what I am telling you!"

SPORTING ACHIEVEMENTS

How To Keep Fit

Billy Brock from Llangwm was too fond of the cream cakes and bitter beer, and he had a problem with his weight. He went to the doctor, who advised him to do some jogging.

"Very good, doctor," said Billy. "But how much should I do?"

"Oh, about ten miles each day should be sufficient." replied the doctor. "Give me a ring in a week's time and tell me how you're getting on."

A week later the phone rang in the doctor's surgery. "Hello, doc," said Billy. "I'm gettin' on fine. I've done about seventy miles so far."

"Excellent," said the doctor. "Come in this afternoon and I'll give you a check to see how much weight you've lost."

"Oh, I can't do that," came the reply. "Can't get back in time - I've just reached Builth Wells."

Golfing Perfection

Up in Heaven, a few years ago, it was all the rage to play golf. Jesus Christ and various of the Saints enjoyed a couple of games per week on the heavenly golf courses which were at their disposal. But Jesus and St Brynach got bored, and one day they decided to go down to earth for a game on a Welsh course. "I know just the place," said Brynach, and he led Jesus down to the Newport Golf Course, beneath the shadow of Carningli where he had spent many days in contemplation during his time on earth.

Before they started off on their first round Jesus said to Brynach: "We've played against one another often enough in the past, old friend. So just to make things more interesting this time, I'll be Arnold Palmer and you can be Greg Norman. What do you think?"

Brynach agreed, and off they went. After a while Jesus played a loose shot which sent the ball clean over the Nevern River to land on a mud bank on the other side. To play his next shot Jesus had to cross the river, and in order not to get his feet wet he walked on the water.

When Jesus was half-way across the river a couple of Newport golfers came by. One of them spotted Jesus and said to Brynach in amazement "Good God! Look at that! There's a chap walking on the water! Who does he think he is? Jesus Christ?"

"Oh no," replied Brynach. "He thinks he's Arnold Palmer!"

A Sound Investment

Bobby Jones from Neyland bought a "thoroughbred" racehorse from a travelling Irishman for £500, having been quite convinced that it would win him a fortune. Bobby's friends were very impressed.

Six months later an old friend who lived in England came to visit Bobby, and he asked him what became of his racehorse. "Oh," said Bobby, "it died."

"Good gracious! That's terrible! All that money down the drain! So what did you do about it?"

"No problem. The horse never came with a guarantee, and God only knows where the Irishman is. So I raffled the beast at £1 per ticket, and unfortunately forgot to mention that it was dead. Made £3000 in no time at all."

The friend was almost speechless. "But didn't anybody complain?" he asked.

"Only the winner," said Bobby. "So I gave him his money back."

A Sporting Chance

It is said that the men of Pembroke always have an eye open for the main chance. One day William, a young man from Pembroke, travelled by train to Tenby for a day at the seaside. He went for a long walk on the beach, and returned to the town along the edge of the golf course. It so happened that as he was passing by a golfer struck a particularly vigorous shot, which resulted in the ball striking William on the head. He fell to the ground, out for the count.

When he came to, he found that he was surrounded by concerned golfers, who insisted on carrying him into the club-house where he was administered a stiff drink. When he was fully recovered he said he must get going so as not to miss his train home, at which point the vigorous golfing gentleman pressed a pound note into his hand and bade him farewell. "Thank you very much, sir," said William. "An' when might you be playin' golf again?"

Hold-up in the Rough

Merfyn and Davy had never played golf before, but stimulated by the wonderful play of the Ryder Cup on the TV they decided that they would take up the game. The borrowed some clubs and balls, and turned up at Newport Golf Course for a round or two. All went well at first, but then the couple behind them on the fifth tee became very frustrated by the hold-up ahead of them. Davy was lying in the middle of the fairway having a snooze in the sun, and Merfyn was nowhere to be seen. Soon there were four couples waiting at the tee, and eventually one of the golfers strode down the course and confronted Davy. "Why don't you help your friend to find his ball?" he shouted.

"Oh, he've got his ball all right," replied Davy. "Down on the beach, he is, lookin' for his club."

In praise of the Obsolete

Old Gethin was fishing peacefully for sewin near the bridge at Cenarth. His rod and tackle were extremely ancient, having been inherited from his

father. But Gethin saw no reason to change his traditional ways. A young visitor came along and took up his station not far away, with a fishing license in his pocket and with gleaming new modern kit ready for a fish slaughter.

"Good evening," said the young man. "I gather this is the place to be. I feel lucky tonight. I've just chucked out my old gear and have gone in for brand new state-of-the-art technology. New super-polyethylene extra-tensile minimum-visibility line, 5th generation high-speed reel, and teflon-coated multiflex fibreglass rod just like the ones they use on the American space programme. Hope you don't mind me mentioning it, but I don't fancy your chances with that obsolete gear you've got there."

Old Gethin shrugged and got on with his fishing, as did the youngster thirty yards downstream. The young man caught nothing at all, but when Gethin stuffed his fifth gleaming silver sewin into his bag he shouted along the river bank: "Must be off home for my supper. There's nice it's been to meet you. Now there's a funny thing for you -- this evening my old hook just happened to get in the way of five obsolete sewin."

THE FUNNY SIDE OF DEATH

The Death of King Arthur

King Arthur was very old, and he came to Pembrokeshire to die. With his great sword Excalibur at his side, he lay in a small cottage in Bosherston, not far from the place where his old friend Gawain had made his hermit's cell. He was fading fast, and around him were gathered the last of the Knights of the Round Table, also very old and frail.

"My lord, is there anything you want?" asked the grey-haired Sir Launcelot. "Speak, and it shall be yours."

"No, no," replied the dying king. "Just sit me up on my pillow and open the window, so that I may smell the mayflower and the salt breeze from the sea." So they did as he asked.

"Now then, dear friend," he said to the aged Sir Galahad, "hand me my mighty Excalibur, which has served me so well over all these years in my quests and my battles." So Galahad limped to the bedside and put the great sword into the King's hand.

Arthur raised the sword high and summoned up the last of his strength, sitting upright in the bed and facing the open window. "Farewell, my good and true comrades," he whispered. "I shall cast my sword to the wind. Wherever it lands, bury me there." And with his last gasp he threw it with all his might.

So they buried him on top of the wardrobe.

The Right Jones

Dai Jones went to Heaven a few years before his wife; and when she finally arrived she thought she would try and meet up with him again. So she went to St Peter and asked if there was a Mr Jones on his little list of residents. "Madam," replied the Saint, "we have got millions of Joneses here. What is his first name?" Mrs Jones told him, and he said: "Oh dear. That's not good enough. We have thousands of Dai Joneses too. Where did he live?" "In Pembrokeshire", said the good wife. "Still not good enough," said St Peter. "We have hundreds of Dai Joneses from Pembrokeshire. Can't you think of anything else that will help us to check our records?"

After giving it a lot of thought, Mrs Jones said: "Well, he did say as he lay on his death-bed that if I was to sleep with any other man after he

was dead and gone, he would turn in his grave."

"Oh, that makes all the difference," said St Peter. "I know exactly who you are talking about. Up here we call him Revolving Jones."

The Mysteries of Genesis

Three nuns from Merlin's Bridge were unfortunately killed in a car crash, as a result of which they found themselves standing before the Pearly Gates. They were greeted by Saint Peter, who explained that they were required to answer some simple questions before being let inside.

The first nun, who was a young novice, was asked the name of the garden in the Book of Genesis. "The Garden of Eden," she said. "Correct!" said Saint Peter. "Come inside."

The next nun was a middle-aged nun who had lived the holy life for many years. "Now then," said Saint Peter. "I must ask you something more difficult. What sort of animal was it that caused the trouble between Adam and Eve?" "A serpent," said the nun. "Correct!" said the saint. "Come inside."

The last nun was the Mother Superior, renowned for her knowledge of scripture. "Something very difficult for you, my dear," said Saint Peter. "But I am sure you won't have a problem. Now then, what did Eve say to Adam when she had eaten of the forbidden fruit?"

"Oh my goodness, that's a hard one," said the Mother Superior.

"Correct!" said the saint. "Come inside!"

Clear as a Bell

Henry Evans lived in Spittal with his wife and three sons. He was slipping away, and his family did not expect him to last the night. On the advice of the doctor, Smith Solicitor was summoned to the house in spite of the lateness of the hour, to help Henry to draw up his last will and testament. While the solicitor went to work with the dying man the family sat together in the parlour downstairs, comforted by the next door neighbours. The house was a small one, and they could hear everything that went on in the bedroom.

"State exactly what is owing to you," said the solicitor.

"Willie Thomas owes me twenty-seven pounds," answered Henry. "Tommy Jenkins owes me seven shillings and sixpence, Dai Jones owes me ninety-three pounds, Bobby Evans owes me a sack of spuds...."

"Good, good," exclaimed Henry's wife to the listening neighbours.

"His head is clear as a bell, and he's rational to the last."

"Now then," continued Mr Smith. "I must know about all your debts."

"To Harry Reynolds I owe one hundred and ten pounds, to Williams Blacksmith I owe fourteen shillings...."

At this the prospective widow leapt to her feet and ran to the foot of the stairs. "Don't listen to him any more, Mr Smith bach," she shouted. "Poor Henry's ranting and raving with the sickness, and it's clear his mind is gone!"

An Unfortunate Delay

In the bad old days before constables enforced the rule of law up in the Presely Hills, human life was cheap. An old woman from the back of beyond, not far from Mynachlogddu, decided that she could take no more from her drunken, bullying husband. So she saved up her pennies for the best part of a year and hid them in an old pot until she had enough to hire a couple of notorious assassins from down Narberth way.

By arrangement, the two men turned up at the lonely cottage on the moor one winter's day when the old man was away at Newport market. They received their instructions from the wife, hearing that the husband was due back on the track over the mountain shortly after dark. Then they went off to the mountain, found the old trackway and settled down behind a gorse bush to await the

passing of their victim. They sat there in silence in the freezing cold as dusk turned to night. At last, with no sign of the old man, one weary assassin turned to the other and said "He's a very long time coming. I hope to God nothing unpleasant has happened to him."

Made to Last

David Parry had just died, and his wife had the sad task of organizing things for the funeral. She ordered a coffin from Billy Box and then went down the street to Jones Draper to get a shroud. "Good morning, Mrs Parry bach," said Mr Jones. "There's sad I am to hear your news. Bad business indeed."

"Thank you, Mr Jones bach," said Mrs Parry. "Grateful I am for your condolences. Now then, I have come to get a shroud for the dear departed. What will it cost me?"

"Seven and sixpence. Top quality - guaranteed to last a lifetime."

"Seven and six! But, Mr Jones bach, I can get one for five bob at Jenkins Siop Fach."

"That may be," said Mr Jones haughtily, "but you gets what you pays for in this world. I have some experience of Mr Jenkins' shrouds, and you can take it from me, Mrs Parry bach, that if you gets one from him the corpse will have his knees through it in a week."

Making Quite Certain

Clarence Cadaver was none too bright, and had problems getting a job. But at last he was offered a job with Roy Folland the Undertaker, and seemed to be learning the undertaking trade quite well.

One day he was digging on his allotment when an old man on a neighbouring allotment had a heart attack and keeled over on his potato patch. He was apparently very dead indeed, so Clarence went to the nearest phone box and rang up his boss. "Boss," he said, "ol' Freddie Shinkins have dropped down dead on his spud patch. No relatives so far as we knows. What shall I do now?"

"Fetch a spare coffin from the workshop," replied Mr Folland, "and put'n in it. But mind you make sure a's dead first."

About an hour later the undertaker's phone rang again. It was Clarence. "Job completed, boss," said our hero. "A's in the coffin, an' the coffin is in the funereal parlour. I knows for certain that a's dead because I hit'n on the head with me shovel just to make sure."

Doing One's Best

Jenkyn Rees was standing at the Pearly Gates, waiting to be let in. St Peter came out with his big book and asked for his name. "Jenkyn Rees of Pontfaen," replied the new arrival. " I have come to be let in, considerin'

that I have been a deacon of Jabez Chapel and have led a good Christian life."

St Peter looked through all the Reeses on his list but could find no Jenkyn Rees of Pontfaen. "You do not appear to be on my list," said the saint. "Are you sure you have come to the right place?"

"Oh yes indeed," said Jenkyn. "Well known I am in the community for my good works and for spreadin' the gospel far and wide."

"That sounds reasonable," conceded the saint. "I might be able to let you in through the Pearly Gates even if you aren't on my list. But I need more convincing. Have you ever done anything great and noble in your life which would qualify you for heaven?"

"Not that I can think of," said Jenkyn. And then he had a sudden thought, and added "But there was the time I went to Belfast for the Baptist mission."

"Very commendable. What happened?"

"Well, I stood in the middle of the Falls Road," said Jenkyn proudly, "and shouted out at the top of my voice that Jesus loves the Pope and loves Ian Paisley."

"Even more commendable. Up here we like to see signs of such ecumenical goodwill and tolerance. And when would that have been? Ten or twenty years ago?"

"Oh no indeed," said Jenkyn. "That was about thirty seconds ago."

Polite to the Last

Miss Smith was an old widowed lady who moved to Tenby between the Wars for the sake of her health. She had a young maid named Jenny who lived in and looked after her in her ailing years. One cold winter Miss Smith fell ill with the pneumonia, and her condition caused the doctor some concern. She began to recover, but in view of her age the doctor was keen to keep a check on her progress.

"Now then, young lady," he said one day to Jenny, "I want you to call over and see me every morning to let me know about Miss Smith's condition. I think she's getting better, but I need to know how she slept, what her appetite is like, and so forth."

For several days the maid called on the doctor, gave Miss Smith's compliments, and reported on her condition. The doctor felt that the old lady's recovery was well on the way, but then Jenny called in on her regular visit to the surgery and said:

"Good morning, sir. Miss Smith sends her compliments, and she died last night at eight o'clock."

A Very Healthy Place

Old Bertie Philpin from Black Tar was leaning on his gate one day, watching the grass grow, when a couple of hearty ramblers strode up. "Mornin," said Bertie. "Good morning to you, sir!" said the rambling husband. "What a wonderful day! And what a view! It quite takes one's breath away. This must indeed be a very healthy place to live. Tell me, do people live to a ripe old age in these parts?"

"Why aye, boy," replied Bertie. "Almost lives for ever, they do. Nobody have died in Llangwm for nigh on twenty years. That would be exceptin' for Dai Coffin the undertaker. Poor ol' bugger. Died of starvation."

Bad Timing Indeed

Twm Carnabwth, the man reputed to have been the first "Rebecca" during the rural riots of 1839-1844, lived with his wife Rachel in a little hovel near Mynachlogddu. He died under the most unfortunate of circumstances in 1876.

Some months after his death an old friend from distant parts called at the hovel. "Good day to you, Ethel," he said when the wife opened the door. "Five years it must be, since we met. And tell me now then, how is Twm?"

"Oh dear," she replied. "Didn't you know? Died back in September, he did."

The friend was greatly saddened to hear the news. "Oh dear oh dear," he said. "Very sorry to hear it, I am. And how did it happen?"

"Well," said Rachel, "he went out into the garden to fetch a cabbage for dinner, and just collapsed and died."

"How terrible! Whatever did you do?"

"Oh, we managed. We opened a can of peas instead."

Message from India

In Manordeifi Church, close to the banks of the River Teifi near Llechryd, there is a memorial to a young British army soldier who died on active duty in India under mysterious circumstances. The story goes that in due course the Army shipped back a large and oddly-shaped box for burial. It didn't smell too good when it arrived at Llechryd, and on opening it up the soldier's family discovered an extremely large and partly decomposed tiger inside. A telegraph signal was sent off to India to ask whether some

mistake had been made, and to insist that the body of the young man should be returned to the family post haste. Back came the reply from foreign parts, short and to the point: "Tiger in box. Sahib in tiger."

Just Making Sure

Two old timers met in their local in Neyland. "Hast tha heard?" said one to the other. "They've gone an' buried John Palmer yesterday."

"Get away man!" said the other. "Is a dead then?"

Very Unfortunate Business

"They do say that poor ol' John Palmer passed away on the operatin' table at Withybush. Died intestate, so I believe."

"Oh dear oh dear. Sounds like a nasty business. Trouble with the private parts then, was it?"

CHURCH AND CHAPEL

The Very Wicked Monks

In the bad old days there were two very wicked monks, Brother Aeron and Brother Bryn, who belonged to the monastery on Caldey Island. Brother Aeron went to the Abbot, whose name was Pyro, to confess his sins. "Father, I have sinned," he said. "Woe is me, for I have broken my vows of celibacy with a married woman."

"With a married woman!" exclaimed Abbot Pyro. "Carnal knowledge is a mortal sin, my son. Now, you must tell me the name of the evil female with whom you have slept."

"I cannot tell you that, Father. It would not be honourable."

"Aeron, my son, let me be the judge of that. Now who was it? Was it by any chance Llinos the wife of Glyn the Weaver of Penally?"

"No, no, Father, it was not her, but more than that I cannot say.

"My son, your wickedness is indeed terrible. Do you realise that your sin is confounded by your hiding of the truth? Now tell me -- was it Eluned the wife of Merfyn the Miller?"

"Father, forgive me, but it was not her. I cannot reveal to any man who it was."

At last the Abbot tired of his interrogation and said: "Aeron, you have done a dastardly deed. If you will not tell me who has led you astray, away with you and do your penance! Say ten Hail Marys and empty the latrines for a fortnight."

Outside the confessional Aeron met his friend Brother Bryn. "How was it?" whispered Bryn. "What did you get?"

"It went fine," replied Aeron under his breath. "Ten Hail Marys, toilet duty, and a couple of bloody good leads."

Jogging the Memory

Rev Idwal Jenkins was the minister of Hill Park Baptist Chapel in Haverfordwest. One day he complained to Billy Evans, one of the chapel deacons, that his bicycle was missing. "I don't like to point an accusing finger," he said, "but I have a feeling that young Jimmy from Coronation Avenue has pinched it. Do you think I should go and look for it?"

"No no," replied Billy. "That would be very embarrassing. The simplest way to catch the culprit is to preach a sermon on the Ten Commandments next Sunday. When you get to "Thou shalt not steal", look very carefully at the congregation, and sure as eggs you'll spot the guilty person." The minister congratulated Billy on his brilliant idea, and decided to put the plan into effect.

On Sunday morning Rev Jenkins started his sermon in fine style, but as it went on he quite lost the thread of what he was saying and ended in a complete muddle. Afterwards Billy commiserated with him in the chapel vestry. "What on earth went wrong, reverend?" he asked. "Well, Billy," replied the minister, "everything was going fine until I got to "Thou shalt not commit adultery", and then I remembered where I left my bicycle."

A Proper Baptist

A man from Haverfordwest was travelling on an ocean voyage, and was looking forward to arriving back at Fishguard Harbour. However, not far from home a mighty storm blew up and he was shipwrecked on Grassholm Island. He was the only survivor, but huge piles of flotsam and jetsam from the wrecked ship were washed onto the rocks. The storm continued for several weeks, but at last he was spotted by the crew of a passing ship. A rescue party was put ashore, and the men saw that it was covered with fine buildings made from stout timbers, canvas and ships fittings.

The man from Harfat took them on a guided tour, proudly pointing out to them his house, his workshop, his electricity generator, a pub and two Baptist chapels. "Ah, the pub looks very cosy," said the first mate. "I sees that you have got your priorities right." The shipwrecked traveller looked shocked. "Not at all," he replied. "I built this little pub so as to help me to resist temptation." The first mate was somewhat taken aback by this, but then he asked: "The two chapels then. Why have you gone to all the trouble to build two Baptist chapels, for goodness sake?"

"Don't be daft, man," said the man from Harfat. "One has to keep up appearances. That one over by there is the one I goes to, and this one over by here is the one I stays away from."

Heaven is Close at Hand

Two small children from Tenby were speculating on theological matters. Turning to his sister Annie, young Gareth said: "I wonder where God lives." Annie replied: "Huh! That's easy. I knows exactly where God lives. He lives in our bathroom."

"Rubbish," said Gareth. "Your bathroom is far too small. And who told you that anyway?"

"Well", insisted Annie, "I worked it out, because every morning when Daddy goes to the bathroom he prowls back and forth in front of the door in a filthy mood shouting: God, are you still in there?"

Keeping the Sabbath

Brynmor lived in Maenclochog. One fine day he was hammering away at the bottom of his wheelbarrow in the garden when his wife came to the kitchen door. "Brynmor!" she exclaimed. "There's a terrible racket you are making, and on the Sabbath too! What will the neighbours say?"

"I couldn't care less about the neighbours, Blodwen bach," replied Brynmor. "But I has to get me barra fixed for cleanin' out the chicken shed."

"But husband bach, it's very wrong to work on the Sabbath," said Blodwen, full of righteous indignation. "It's screws you should be using."

The Price of Innocence

In Wolfscastle School the teacher was giving a Religious Instruction lesson, and she asked Johnny who had knocked down the Walls of Jericho. "Honest, miss," replied Johnny, "it wasn't me."

The teacher was most concerned at Johnny's lack of religious knowledge, and next time she met his mother in the street she said: "I'm very worried about young Johnny. When I asked him who had knocked down the Walls of Jericho he simply said that it wasn't him. He should know better." Immediately Johnny's Mam became very irate, and said: "Don't you dare accuse my Johnny. If he said he didn't knock the Walls of Jericho down, then he didn't do it."

Now the teacher was even more concerned, and some days later she called in to see Johnny's father. She told him about the episode, and immediately he took out his wallet. "Now then, Mrs Jones bach," he said. "We don't want any trouble at the school. Just tell me how much that wall cost, and we'll put things right straight away."

A Delicate Question

Young Joshua Williams and his pretty wife Megan were faithful members of Bethesda Chapel in Haverfordwest before their marriage, but after the happy day their attendance at Sunday service fell off somewhat. The Minister, Rev Hopcyn Hopkins, called round to see if there was something wrong. "Well, reverend," said Joshua, "we have a difficult and delicate question of religion which Megan and I can't decide for ourselves. What we want to know is whether it is all right for us to have sex after chapel on Sunday mornings."

"Now that is a very difficult question," replied the minister. "I shall have to consult with the deacons about it." He went away, and Joshua and Megan heard nothing more until a fortnight had passed. Then Rev Hopkins called round again, and was welcomed into the house. "We are very glad to see you," said Megan. "So what decision have you come to?"

"We had a very lovely meeting about it," replied the minister. "The discussion went on for five hours, and we examined the matter from many different angles."

"Yes, but what did you decide?"

"Mr Willy Williams spoke with great eloquence, and left me greatly moved," said the minister.

"Yes, yes, but what was your theological decision?"

"And Mr Tommy Thomas gave us a most learned discourse quoting many wonderful thoughts from the scriptures."

"But what conclusion did you reach, Mr Hopkins?"

"Oh, at the end of it all we decided it is all right, provided you don't enjoy it."

Preaching in Camrose

The minister of a Camrose chapel had been there so long that no one could remember anybody else. In all the years of his ministry he had never allowed anybody else to occupy his pulpit, and he had never missed a Sunday through illness.

On one occasion a young student home from theological college called at the manse and asked the minister if he might be allowed to give the sermon on the following Sunday. "We are told by our Principal", he explained, "that we need practical experience to see how well we are suited to the ministry."

"My dear young man," said the minister, placing a hand on his shoulder, "if I let you preach on Sunday morning and you give a better sermon than me, my congregation would never again be satisfied with my preaching; and if you're not a better preacher than me, you're not worth listening to."

Personal Religion

Visitors to Pembrokeshire are often confused by the multiplicity of churches, chapels and religious denominations which confront them on all sides. The tendency towards schism continued until quite recent times.

Gomer Griffiths and his wife Nansi, together with a few friends, split off from their local Baptist Chapel because they could no longer accept its doctrines. At least, that was their story. The real reason was that Mrs Jones Penbanc forgot to put Nansi down on the rota for flower arranging.

Some months later the minister met Gomer and during the course of their conversation he asked him whether he and the others were worshipping together.

"Well, not exactly," replied Gomer. "We have discovered certain differences between us, so Nansi and me have withdrawn from Communion with them."

"That is very unfortunate," said the minister. "So I suppose you and your wife carry on your devotions together at home?"

"Well, not exactly," said Gomer. "We found that our views on certain doctrines were not in harmony, so there has been a division between us. You see, I have discovered that I am by inclination a United English Reformed Presbyterian. She, on the other hand, is instinctively a Traditional Welsh Wesleyan Baptist. She therefore worships in the kitchen, and I take the living room."

A Gift for God

The Salvation Army were involved in a mission in Pembroke Dock, and at one of their meetings an old tramp, who hailed from Cardigan, decided to go along in order to enjoy the warmth and the music. He had a splendid time, and got a bowl of steaming soup into the bargain. At the end of the meeting a pretty young lady in Salvation Army uniform went round with a bowl, asking all those present whether they would give "sixpence to God."

When she came up to the old tramp he said to her "Tell me, young lady, how old are you?" "Well," replied the girl, "that's a very personal question, but I'll tell you anyway. I am twenty years old."

"Is that so?" replied the Cardi. "There's nice, and very pretty you are too. But I'll tell you what. I'm seventy-five, and I've only got threepence in me pocket. I'll no doubt be seein' the Almighty afore you do, so I'll give him the threepence meself."

Small Incident on the Haven Road

Once upon a time, not very long ago, an elderly spinster lived in a tidy bungalow on the Haven Road in Haverfordwest. She was a faithful member of Bethesda Chapel, and led a sheltered, comfortable and God-fearing life. One day two GPO workmen had occasion to repair a fault on a telephone pole outside her home. Bill was up the pole mending the wires, and Tommy was on the ground below, sorting out the tools for the job. Suddenly the elderly spinster was shocked to hear a string of expletives, some of which she had never heard before and others were distinctly blasphemous. She remonstrated with the men and later wrote a letter of complaint to the local GPO manager.

The manager called the culprits into his office and asked for their version of events. "Well, sir," said Tommy, "It were like this. Me an' Bill was on the job, fixin' the line. A was up the pole an' I was down below findin' them wire cutters from the bag. Then Billy let some hot lead drip on me head and dropped his heavy hammer on me foot. So I said to 'n as tidy as you like: Now then, you really must be more careful, William."

Enlightenment is at Hand

The little Methodist Chapel at Portfield Gate had to depend for many of its Sunday services upon the goodwill and commitment of various lay preachers. One day the appointed lay preacher fell ill, and so the service had to be taken at very short notice by one of the chapel stewards. All

went well with the hymns and prayers, but then came the time for the sermon. Old Billy Evans stood up in the pulpit, shaking with nerves.

"Friends," he said. "This is all a bit new to me, never havin' done no sermonizin' afore. But I'll have a l' bash at it with the help o' the Good Lord. There's many great mysteries for this world that you an' me knows nothin' about. But the Lord knows everythin'! So he is goin' to help me this mornin' - I feels it in me bones - to unscrew the unscrewtable."

Uncommonly Good Potatoes

It was the month of August, and in spite of the beautiful weather the minister of Tabernacle Chapel had a troubled look on his face as he prepared to launch into his Sunday morning sermon. He gave out his text and then said "Friends, I have found it difficult to expand this text today, as the commentators do not agree with me." Somehow these words lodged in the brain of Freddie Thomas as he sat in the back row, unable to concentrate on the dense exposition that followed.

Next day the minister was in his study in the manse when Freddie knocked at the door. The reverend gentleman was surprised to see that he had with him a large sack of potatoes. "Good gracious, Freddie," he exclaimed, "Is this for me?"

"Indeed it is," said Freddie. "I couldn't get it out of me mind what tha' said yesterday about them common taters not agreein' with thee. So I thought to meself, my taters are uncommon good this year. Then I thought I'd better bring thee a bagful so as to set thee to rights again."

The Best Dad in Harfat

Three small boys from Honey Harfat were earnestly discussing the abilities of their respective fathers. One of them, who was the son of a "Western Telegraph" journalist, said: "My dad came home the other evening, wrote an article in three hours after supper, and got paid five pounds for it." The second boy, who was the son of a local photographer, said: "My dad spent a couple of hours taking pictures of an old lady the other day, and got paid ten pounds for it."

The third boy, who was the son of the minister of Wesley Chapel, was at first non-plussed. But then he had a heavenly inspiration. "The other day there was a big do going on in the chapel," he said. "My dad got up in the pulpit and talked for twenty minutes, and then it took twelve men to carry all the money up to him."

A Blessed Mistake

There was a very posh wedding in St David's Cathedral, by special dispensation of the Bishop. All the crachach were out in force, for the bride was from a prominent local family. The cathedral was packed out with the great and the good. The bridegroom was serving with the Welch Regiment overseas, and the arrangements for the wedding had been made somewhat hastily over the telephone. In checking the details with the young man, the Rural Dean had asked "Are you sure you want hymn number 774?"

"Oh yes," had replied the prospective groom. "I have the hymn-book in front of me right now, and it is exactly the right hymn for such a wonderful occasion."

So that was that. The bridegroom arrived on leave shortly before the start of the wedding service, and all went according to plan until the congregation started to sing hymn number 774. Then, as the assembled voices should have risen to a great crescendo, uncontrollable giggles followed by gales of laughter caused the hymn to be abandoned, and the organist fell off his stool. This is what the congregation was trying to sing:

Come O Thou traveller unknown,
Whom still I hold but cannot see,
My company before is gone,
And I am left alone with Thee.
With Thee all night I mean to stay
And wrestle till the break of day.

Somehow or other the wedding ceremony was completed with the congregation in a state of high euphoria, with the poor bride covered in embarrassment and the groom realising that the Methodist hymn book is not the one normally used in St David's Cathedral.

Holy Teamwork

A holidaymaker who was staying near Haverfordwest decided that he would go along to the Sunday morning service in the little Methodist Chapel at Portfield Gate. After the service he chatted for a while with the old gentleman who had taken the collection.

"Very nice service indeed," he said. "The prayers and the singing were marvellous. Most uplifting. But the sermon went on a bit, and it was most upsetting that the learned discourse was interrupted every now and

then by the organist with her coughing."

"Oh don't you worry about that," said the old man. "That's holy teamwork for you. Maisie coughs once when five minutes is gone, twice when ten minutes is gone, and three times after a quarter of an hour. Today the pastor got a bit carried away, an' forgot the signals. The terrible fit of coughin' that Maisie had after twenty minutes usually means that the roast beef is burnin' in the oven, an' that if the last hymn don't come quick she's off to rescue the Sunday dinner!"

A Good Offer

In the 1920's and 1930's the temperance movement was in full swing in Pembrokeshire, and the local nonconformist churches were involved in frequent campaigns and public meetings designed to demonstrate the evils of drink.

One day a temperance speaker was on his soap box in Castle Square, Haverfordwest, working himself up to a crescendo on his favourite theme. "It all starts with tobacco!" he shouted. "You think all you need is a quiet smoke! So you dash into the tobacconist around the corner and put down your money for a packet of Woodbines. But that, my friends, is not the end of it. You mark my words, for in the wake of those twenty cigarettes will follow beer, red wine, cider, rum, brandy and even whisky!"

"My goodness, that sounds like a wonderful offer," came a voice from the crowd. "Please to tell me the name of your tobacconist!"

Pastoral Visit

The new vicar at Maenclochog was getting to know his flock, and one day he called in to see Mr and Mrs Joseph Jones in their nice villa on the main street. He was given a warm welcome, and according to tradition he was accorded the privilege of having tea and bara brith in the front lounge.

The three of them sat in comfort, and the vicar greatly enjoyed his cup of tea and plate of excellent cake. But as he and the old couple chatted away he became concerned that while her husband tucked in Mrs Jones was not partaking at all in the refreshments. "Now then, Mrs Jones bach," he said. "You have made this wonderful cake and pot of tea. Aren't you going to share it with us?"

"Never mind about me, Reverend bach," replied the old lady. ""I'll have a bit of cake and a cup of tea with you later on, but first I has to wait till Dad have finished with the teeth."

MAKING A FEW BOB

Not Actually Needed

Gerald James had a little general store in Haverfordwest before the First World War. One Friday in the year 1910 he was behind his counter when a very scruffy little boy came in, looking somewhat ill at ease. Gerald had never seen him before. "What can I do for you, young man?" he asked. "Please sir, my mam says please to sell me a roll of toilet paper."

Gerald took down a roll from the shelf and said "That will be threepence, please." The boy paid over the money, took the toilet roll and scuttled out of the shop.

First thing on Monday morning the little boy was back again, carrying the toilet roll under his arm and carrying a letter in his hand. "Please sir," he explained, "my mam says please to read the letter." Gerald opened it up and read as follows:

"Dear Sir, Billy is taking the roll of toilet paper back to you, and please to pay him the money back what he paid you. We will not be needing the toilet roll. Our visitors never came."

No Comparison

Once upon a time there was a prosperous businessman in High Street, Haverfordwest, by the name of Billy White. His business was a thriving one, but when he died it was taken over by a Chinaman named Mr Wong. He had little idea of how to run a business, and things started to decline, and then went from bad to worse. At last his brother came down from London in order to help out -- but it was to no avail, and the business was eventually declared bankrupt. Afterwards the sad episode was said by many people in Haverfordwest to prove quite conclusively that two Wongs can never make a White.

Tony's Wonderful Pig

An English visitor was on holiday in Begelly with his family. Next door to the holiday cottage there was a farm, and the Englishman was intrigued to see that one of the pigs in the farmyard had a wooden leg. At last he could contain his curiosity no longer, and went to ask the farmer about the pig.

"Well now," replied Tony the farmer, "that pig is a very remarkable animal. One night when we were all asleep, the house caught fire, and the pig woke us all up and got us out of our beds, and then put out the fire.

A few months ago he was out digging in the field, and he discovered a seam of coal which has brought me in a small fortune. And just now he's taking a course in Business Management at the Pembrokeshire College."

"Quite amazing," said the English visitor. "But why the wooden leg?"

"Good God!" said the farmer. "You don't expect me to eat a pig like that all in one go, do you?"

A Matter of Priorities

Harri Holy Spirit, who owned a little grocery store in Tregaron, was shutting up shop for the day. As he counted the day's takings in the back room, his assistant Alwyn was pottering around the store tidying things away. "Put up the blinds, have you, Alwyn?" he asked.

"Yes. Blinds up nice and tidy."

"Sanded the sugar, have you, Alwyn?"

"Yes sir. And all bagged up ready for tomorrow."

"Watered the vinegar, have you, Alwyn?"

"Yes indeed. And in case you asks, the dates on the eggs is changed and the scales is adjusted three ounces."

"Good, good. Hurry up then and lock up, or late we will be for the prayer meeting at Tabernacle."

Not Intimidated

"Well then," said Johnny Jacket, the Cardigan tailor, to his assistant, "did you collect the money that Mr Mathias Ty Mawr has owed me this last twelvemonth?"

"No sir," replied the boy, looking somewhat dishevelled. "I gave him the Final Reminder and asked him would he kindly pay what he owes us. Then he hit me over the head with the waste-paper basket, kicked me up the backside, twisted my arm and threw me down the steps into the street, where I got ran over by a man on a motor-bike."

"So that's his attitude, is it?" said Johnny Jacket, furious. "Now just you go straight back again and collect that bill off him. I'll show the bugger that he can't scare me!"

Value for Money

Gethin Griffiths was a farmer who lived near St Davids. Business was going quite well, and he wanted to buy a cow from his neighbour Dilwyn. However, on enquiring as to the price he was shocked to learn that Dilwyn wanted £50 for it. "Duw Duw, Dilwyn bach," he protested, "here am I, a good neighbour of yours all these years, and you want to charge me fifty quid for that old cow?" "Well," replied Dilwyn, "seein' as how you and me are good old friends, I'll give you 20 per cent discount."

Now Farmer Griffiths was not too good at the mathematics, so he said: "A reasonable offer, Dilwyn, but I'll need a couple of days to think about it."

Next day he was in St David's to do a spot of shopping. He was walking across the square pondering deeply about percentages and discounts when he saw the local school-mistress coming towards him. Suddenly he had a bright idea, and beckoned the good lady towards him. "Now tell me, Miss Llewellyn," he said, "if I was to offer you £50, less 20 per cent discount, what would you take off?"

Miss Llewellyn thought for a moment and said: "Everything, except my ear-rings."

Business is Business

Shortly before Christmas, a commercial traveller was visiting Aberaeron looking for new accounts. He called in at Morris Mars Bar, the confectioner on the main street, and felt that the discussions were going along quite promisingly. With a view to cementing a deal, the rep then said: "Mr

Morris, we are offering a free bottle of Scotch whisky as a Christmas gesture this year to every new account."

"Dear me, no," said Mr Morris, looking shocked. "There's wicked it would be for me to take a gift from you like that. They do say that bribery is a terrible thing."

"But is is only a small gift," suggested the commercial traveller, "and if you don't care to take it from me as a gift, pay me a nominal sum for it. Shall we say ten pence?"

"There's nice of you," said Mr Morris, brightening up considerably. "Now that you have made it a business proposition, I sees no objection. Thank you very much, and I'll take three."

Order of Priorities

One of the great characters of the Pembrokeshire agricultural scene was Douglas Morris of Burton. He was one of the pioneers of local turkey breeding, and he built up a successful business which he ran from his farm. He sold many thousands of fresh turkeys to local butchers shops, but in the early days he also sold directly by advertising in the local press. One year, long before the advent of the ansafone, he placed the following advert in the *West Wales Guardian*: "Top quality fresh turkeys for sale for your Christmas table. Buy local for best value. Phone your order now, but not during the News or Tom and Jerry."

Still Under Guarantee

One spring Davy Evans from Newport bought a beautiful new watch from Munts the Jewellers in Haverfordwest, complete with a twelve month guarantee. Shortly before Christmas he called in at the shop again with the watch in his hand. "Good day to you, Mr Munt bach," he said. "I has come to get my new watch fixed with you, being that I has a guarantee."

Mr Munt looked at the watch and commented that it was in a terrible state. He asked what had happened to it.

"Well now," said Davy. "It stopped workin' about six months ago, on account that it fell into the pig trough when I were feedin' the pig."

"Fair enough," said Mr Munt. "But why didn't you bring it in for repair at once?"

"Don't be daft, Mr Munt bach," replied Davy. "How could I? We only killed the pig yesterday."

Abraham's Fire

Abraham Arabia was a successful Jewish businessman who had a thriving draper's shop in the main street of a Pembrokeshire town. One day he was in Haverfordwest on business, and Charlie James the Cobbler met him on the street. "Good day, Abraham," said Charlie. "I was very sorry to hear the sad news."

"What sad news?" asked Abraham.

"About your shop going on fire last Tuesday. Isaac Evans told me."

"Husht, you fool!" exclaimed Abraham. "Don't talk so loud, somebody will hear you. It is **next** Tuesday."

Tenby Rabbit Pie

Before the scourge of myxomatosis afflicted Pembrokeshire, a certain restaurant in Tenby was famous for its rabbit pie. But then, with the coming of the disease, the proprietor, Joseph Jones, found it increasingly difficult to get rabbit supplies. The customers, some of whom came from as far away as Penally just for the rabbit pie, noticed a distinct decline in the taste and texture of the meat. Eventually the rumour went around that the restaurant was using horse-meat in the pie, and one day some of the customers confronted the proprietor.

"Joseph", said one, "your rabbit pie is not what it used to be. Now then, give us a straight answer to this question: are you using horse-meat in the pie mixture?"

Yes, indeed," said the boss. "I have nothing to hide. Rabbits are not easy to find these days, and I find that a bit of horse-flesh adds greatly to the subtle flavour of the pie."

"So how much horse-meat do you use?" "Half and half."

"You mean fifty-fifty?"

"Of course," replied Joseph. "Don't I make myself clear? One whole horse to one whole rabbit."

There's Money in Sheep

Lenny Badd, who died a few years ago, was a well-loved local character who ran a small sheep farm on the flanks of Carningli, near Newport. According to local legend, one day while his wife was dyeing a bedspread a little molly lamb which was in the kitchen fell into the bucket of dye and emerged bright blue in colour. Lenny immediately realised its novelty value and sold it to a passing English tourist for fifty pounds.

He realised that he was onto a good thing, so he dyed all his other lambs in bright colours and sold them at a vast profit to other holidaymakers. With the money he made he bought all the other lambs in Pembrokeshire, dyed them red, and green, and purple and yellow, and made even more money. And before long Lenny was the biggest lamb dyer in the whole of Wales.

Buying Some Land

Back in the bad old days many English people were attracted to Pembrokeshire by the low price of land. It became all the rage to purchase properties for use as retirement or holiday homes. One smart operator from London liked the look of a farm not far from Wiston, which was rumoured to be shortly coming onto the market. He thought that if he moved fast, he might be able to acquire it for a song.

He went to visit the farmer, who turned out to be an old man living in squalid conditions. "Good day to you, sir," said the Londoner. "I am interested in buying some of your land."

"How much?" asked the farmer.

"About a thousand pounds' worth," said the visitor, waving his arm out over the rolling countryside.

"Come back tomorrow then," said the old man evenly. "And don't forget your wheelbarrow."

The New Boss

Thomas, Jones, Williams & Co was an old-established building firm in Pembroke Dock which fell upon hard times. It was taken over by a rival firm called Evans, Davies, Hughes & Co. Mr Meredith Evans was the brash and energetic boss of the newly combined company, and he determined that he would knock the work-force of TJW into shape so that they could make a proper contribution to the profits of the new organization.

One day he made an unannounced visit to a building site in the dockyard town where the TJW workers were completing a housing contract. He found a number of things which he didn't approve of, and decided that decisive action was needed. So he summoned the foreman and said to him "Jim, there are a number of things here that have to be put right. There are too many bricks lying about, the timber needs to be covered over, and the concrete mixer is in a terrible state. And by the way, I have just caught a fellow hanging about by the shed, smoking during working hours. I sacked him on the spot, told the girl in the office to give him a week's wages and saw him off the site.".

"Very good, Mr Evans, sir," said the foreman with a grin. "I knows all about it, for I seen the man leavin'. That was Tommy James from Pennar, who just called in on the off-chance to see if I could give 'n a job."

Value for Money

Dai and Iorwerth Rhys were bachelor brothers running a small farm up in the hills near Brynberian, with a bit of contracting work and dealing on the side. One of their sidelines was the collection and disposal of fallen animals.

One sad day, Iorwerth fell under a tractor and was killed. After making the necessary arrangements for the funeral, Dai thought he had better let the world know, so he rang the "Western Telegraph" office in Haverfordwest.

"I want to put a Death Notice in the paper," he said. "How much?"

"Certainly, sir," said the young lady. "Minimum nine words, and the cost is £5. What do you wish to say?"

"Put this: Iorwerth Rhys is dead."

"Very well," said the girl. "But you can have another five words for the same price."

Dai thought for a moment, and then, being a consummate businessman, he said: "You can add this: We also buy dead cows."

The Upwardly Mobile Delivery Boy

Mr Sidney Bowler had a big grocery shop in High Street in Haverfordwest. It was a busy and successful business, having grown from very modest beginnings. According to legend, when the business was very young the staff consisted of Mr Bowler himself and a fourteen-year-old lad who did the deliveries.

One day the lad came to Mr Bowler and said "Sir, I feels ashamed goin' to all your customers lookin' so tatty. Me trousers is full of holes, and there's hardly nothin' left of me shoes. Me poor ol' Mam an' Dad haven't got a penny to spare, so what am I to do?"

Mr Bowler was greatly moved by this plea from the heart, and so he gave the boy a guinea from his modest savings, telling him to go out and get some new clothes and shoes.

Next day the boy was absent from work, but in the evening Mr Bowler met his mother on the street and enquired whether he was unwell. "No no, Mr Bowler," she replied. "A's very well thank you. Indeed, thanks to you a was lookin' so smart this mornin' that I thought I'd better send'n round town to see if a could get himself a better job."

Money Management

Tommy Mathias from Freystrop was new to bank accounts, and had a bit of trouble learning all the ins and outs of using cheques instead of real money. The bank manager in Haverfordwest told Tommy that he must look after his brand new cheque book very carefully, so he was very worried when he

lost it in the middle of the crowd of shoppers in Bridge Street one Saturday morning.

Tommy went back to the bank on the following Monday to report the loss to the bank manager. "In me pocket one minute, it was," he explained, "but next minute gone, in front of Charlie Cook Butchers. And not a single cheque used up. So I've come to have a new one with you."

"Oh dear," said the bank manager. "This is very serious. Have you reported the loss to the police?"

"No no," replied Tommy. "No need for that. I ain't so stupid as I looks. Nobody else can use me cheques, since I made sure to sign every one of them meself as soon as I had the cheque book with you the other day."

Almost Without Trace

Barry John Carpet-man was doing a job for a customer in Fishguard. It was a long job, involving the fitting of wall-to-wall deep pile carpeting in the lounge, dining room and three bedrooms. He had just finished the whole job, and was making a final check that all was well, when he noticed a lump under the new carpet in the middle of the living room floor. He cursed under his breath and thought that he might have dropped his packet of cigarettes while working on his hands and knees. He checked in his pockets, and sure enough the cigarettes were missing.

There was no way he was going to lift the carpet and re-lay it just for a packet of cigarettes, so he jumped up and down on the lump for a while until the carpet was beautifully flat again. Then he gathered up his tools and took them out to his van on the street outside. He took his leave of the good lady of the house, and opened the driver's door of the van. Just then two things happened simultaneously. He saw his packet of cigarettes on the driver's seat, and over his shoulder he heard the housewife call out: "By the way, have you by any chance seen my budgie anywhere?"

Reasonable Profit

A Cardigan chemist was making up a prescription for a customer whom he had never seen before. Having put the twelve purple pills into the little bottle, he turned to the customer and said "There you are, sir. That'll be £4.50 please."

Just then the phone rang, and the chemist turned to answer it. He had a brief conversation, and when he turned round again the customer had taken the bottle of pills, put a 50p piece on the counter, and left the shop.

The chemist rushed after him, shouting "Sir! Sir! The price is four pounds fifty, not fifty pence!" But the customer had disappeared without trace.

So the chemist returned to the shop, picked up the fifty pence piece, and tossed it into the till. Shrugging his shoulders, he said with a resigned look on his face "Oh well, I suppose that forty pence profit is better than nothing!"

Not Such a Fool

Billy Loose Cog lived in Hakin, and he was reputed to be a bit slow in the head. The local teenagers would have great fun at his expense by offering him two coins, a penny and a half crown. Without fail Billy, with a

radiant smile on his face, would choose the penny and leave the half-crown in the hand of the latest joker. And always this would cause hoots of laughter from the rest of the cronies..

One day somebody asked Billy why he never chose the nice shiny silver half-crown instead. "Huh!" replied Billy. "I ain't so stupid as I looks. I gets offered pennies an' half-crowns about twenty times a day by all them silly buggers. If I was ever to choose the half-crown they would pretty soon stop offerin' me either the half-crown or the penny, an' then where would I be?"

That's More Like It

A smartly-dressed customer walked into Griffiths Grocer in Narberth one day and explained that he was looking for some exotic cheeses for a very important dinner-party. He insisted that the cheeses were to be "fairly lively", but after being shown some Brie, some Gorgonzola and some

Danish Blue, he was not satisfied. He could not even be encouraged to approve of an extremely ripe Danish Havarti. At last, having exhausted all the possibilities, Mr Griffiths was moved to sarcasm. He turned to his assistant and said "Now then Jimmy, you'll have to go out in the yard. Take that No 9 mature Cheddar off the chain and bring it in, but watch out that the bugger don't bite you."

A Most Historical Chair

Fred Furniture ran a little antiques business in one of the back streets of Pembroke Dock. He was reputed to be able to sell anything to anybody. One day a wealthy young man from the Dockyard came along with his new wife, looking for furniture for their home. Their eyes were taken by a very fine chair which was standing in the corner covered in dust. Fred pulled it out for them to look at.

"This chair is yours for £200," said Fred. "A most historical chair, it is."

"What do you mean?" asked the young man. "It just looks like an ordinary chair to me."

"Ordinary, by God!" exclaimed Fred. "My dear sir, this is the very chair that Hywel Dda sat on when he and his Parliament made all them Welsh laws at Whitland."

"But look at the dovetail joints and the raffiawork seat -- it doesn't look more that fifty years old."

"Appearances can be deceptive, my dear sir," said Fred. "This here chair may have had two new backs, three new seats and several sets of new arms and legs since it was made, but I can assure you from my extensive research that it the **very** chair of which I have spoke!"

LOVE IS A MANY SPLENDOURED THING

The Dreadful Secret

Glyn and Catrin both lived in Puncheston, and everybody in the village was delighted when they announced their engagement to be married. On the day before the wedding Catrin said to Glyn: "Cariad, before we get married there is something dreadful about my past life that I must tell you." "No, no," replied Glyn. "I love you the way you are, and I don't want to know anything about your past. If you must, tell me after we are married."

After the wedding, when the happy couple were on their way to Wolfscastle for their honeymoon, Catrin tried to raise the matter of her dreadful secret again. "I won't hear of it," said Glyn. "But if you insist you can tell me when we are in bed together; that'll be soon enough."

So that night as they got into bed together Catrin finally revealed her secret. "I have to tell you, Glyn bach," she said, "that I am still a virgin." Glyn was flabbergasted. He let out a mighty yell, leaped out of bed, put all his clothes back on and said: "This is terrible! I have to go back and talk to mother about this!" And with that he rushed out of the hotel, leaving poor Catrin weeping in the bridal bed.

When he got home his mother exclaimed: "Good God, Glyn! What are you doing here? I thought you was on your honeymoon?"

"So I was, Mam. But things will never work out. I have had to leave Catrin, for it seems she is a virgin."

"Well I never!" said his Mam. "Who would have thought it! What a disgrace on the family. But you did quite right, bach. If that there Catrin Evans is not good enough for the rest of the village she's not good enough for you."

Making an Effort

Billy John from Llangwm was a splendid fellow and a new member of the local rugby team, back in the days when they used to win matches. He had been courting Kathy from Hook for several years, and at last he plucked up the courage to ask her to marry him. "Most kind of you to ask," said Kathy, "and I am inclined to say yes. But to be honest with you, Billy, I

have a bit of a problem with you. Since you took up playin' rugby, your bodily odours on a Saturday night are very nasty indeed. So I'll say yes, but only on condition that you starts to smell a bit fresher. I wants you to promise that every day from now on you'll have a nice bath and put on plenty of deodorant and toilet water."

Billy promised faithfully that he would do anything for his beloved, and as he took his leave he promised that when next they met, on Saturday night, be would be smelling fresh as a dew-covered daisy.

When Saturday night came the couple met as usual outside the Hook post office, and Kathy was amazed to see that Billy's head was covered with bandages. "Oh Billy," she exclaimed. "What on earth have you done? Did some horrible rugby player from Neyland jump on your head in the match?"

"Nothin' so simple," replied Billy. "After the match I went home, had me supper, and had a nice bath. Then I put on the deodorant like you said. But then when I was splashin' on the toilet water the toilet seat fell on me head."

Looking for a Bargain

A young man called Ianto was travelling on the Cardi Bach from Whitland to Cardigan. He was all alone in his compartment until the train stopped at Crymych, when a very beautiful young lady got in. Ianto was feeling full of the joys of spring, and at last he plucked up his courage and said "Good afternoon, miss. I wonder if you would allow me to kiss you if I was to pay you ten shillings?"

"Certainly not!" said the young lady, looking very affronted.

The train went on, very slowly, for a mile or two, and at last the young man said "I wonder if you would allow me to kiss you if I was to pay you ten pounds?"

There was a long pause, after which the young lady blushed and said "Oh, all right then."

The young lady closed her eyes and awaited developments. But Ianto remained in his seat for several minutes more. The kiss did not materialise, and at last he said "I wonder if you would allow me to kiss you if I was to pay you one pound?"

Then the girl got angry and shouted "No, I will not! What kind of a girl do you take me for?"

"We have already established that," replied Ianto, like a true Cardi. "Now we are just haggling over the price!"

THE TROUBLE WITH THE LAW

Dafydd Daft and the Jury

Dafydd Daft was always in trouble with the law, and he had been hauled up before the Eglwyswrw magistrates many times. This time he had gone too far, and his crime justified a trial before a judge and jury in the County Court. When the jury had been selected the judge looked at the downcast prisoner in the dock and said "Dafydd, it is now your privilege to challenge any member of the jury now being impanelled."

At this, Dafydd brightened considerably. "Thank you, your honour," he said. "I'll fight the small man with one eye over there at the end of the front row."

Quite Nice Indeed

Not very long ago, a drugs case was being heard at the Pembrokeshire Quarter Sessions. During the presentation of the evidence, samples of the illegal substances -- in the form of small white tablets -- were passed over to the members of the jury for them to examine. Eventually, upon the completion of all the evidence and the closing addresses by the prosecution and defence, the jury went to the retiring room to consider their verdict.

They were closeted away for an inordinately long period of time, and occasionally loud bursts of laughter were heard by the constable at the door. At last a message was passed out by the foreman of the jury and was handed on to a senior Court official. In turn he approached the judge. "Your Honour," he said. "There is a message from the jury. They say they

are having a wonderful time considering the intricacies of this case. They also say that they really enjoyed those little white sweets, and ask if you will be kind enough to have some more sent in to them!"

Dafydd Daft Helps Out

Dafydd was up before the Eglwyswrw magistrates again, this time for deserting his wife and children. After hearing all the facts of the case, and failing to hear of any mitigating circumstances from Dafydd or his solicitor, the magistrates went into recess. At last they returned, and the presiding magistrate said: "Mr Daft, this is a very serious matter, and there appears to be no excuse for your irresponsible behaviour. I therefore award your wife £100 a month." "That is most kind of you indeed, your honour,"replied Dafydd. "In fact I'll try and give her a few quid myself now and then"

Getting Off Lightly

Old Albert Jones had fallen on hard times. He had never committed a crime before, but one day he heard from some disreputable characters in his local pub in Hakin that it was possible to survive quite nicely on a spot of occasional shoplifting from the shiny new Tesco store down by the station. So one Saturday morning he went into the superstore and slipped a tin of pears into the inside pocket of his jacket. His wicked deed was picked up on the security cameras, and outside he was grabbed by the store's detective. He was hauled before the manager, and so the cogs of justice began to turn.

In due course Albert had to appear before the magistrates. The chairman of the bench heard the evidence, and having then examined the tin of pears he asked Albert whether this was his first offence. Albert nodded miserably. "We have to deal with these matters very severely," said the magistrate, "or civilisation will collapse around our ears. Now then, I want that tin of pears opened and the contents counted." The Clerk of the Court found a tin-opener, did the honours, and reported that there were four pears in the can. "Now just you listen to me," said the magistrate. "Albert, this is your first offence, and I shall be lenient. I am going to sentence you to four days in prison, one for each pear that you stole. And let that be a lesson to you!"

"Thank you, yer Honour," said Albert, greatly relieved. "And thank God I put back that bloody tin o' baked beans!"

LIFE ON THE MOVE

Trouble on the Railway

The Great Western Railway was being built on the outskirts of Haverfordwest, and hundreds of Irish navvies were billeted in the town. Almost every night there was trouble in the public houses of Prendergast, and free-for-all fist fights were particularly common on pay-days when there was ready cash about and when the ale flowed freely. One day a group of battered navvies, swathed in bandages and hobbling on crutches, were brought before the local magistrate. Seamus O'Malley was asked by

the magistrate to describe the circumstances of the fight which had occurred outside "The Bull" on the previous Friday night.

"Well now, yer Honour," replied Seamus. "Billy Murphy got in a bit of an argument wid Pat Dooley out on the street. Pat smashed Billy over the head wid a chair and busted his head open. Then Billy's brother Mike carved Pat up wid a butcher's knife, and Barry Flanagan got a shot-gun and shot Mike through the leg. Charlie Casey went at Barney wid an axe, an' then, yer Honour, we jus' naturally got to fightin'."

Tragedy in Clarbeston Road

An old farmer who lived near Clarbeston Road had a fine herd of milking cows. His land was bisected by the GWR railway line, and when the fields on the far side of it were being grazed he had to drive his cows across the line four times a day - twice over and twice back - for milking. One day there was a sad accident, and his best cow, whose name was Margaret, was struck by a train on the level crossing and killed. He complained to the GWR and was sent a claim form to fill in. For hours he struggled with question after question, filling in the answers as best he could. Then he came to the last item, which read "Disposition of the carcass?" He puzzled over this for a very long time, chewing the end of his pencil. At last he wrote, quite truthfully: "Kind and gentle".

Getting off at Whitland

In the good old days there was an overnight GWR sleeper train between Paddington and Milford Haven. "Now then," said a passenger as he climbed aboard at the London end, "I must get off the train when we arrive at Whitland. Will you kindly wake me and put me off there?"

"Yes indeed, sir," replied the guard. "It will be my pleasure." And he received a handsome tip, in advance, from the passenger.

"And by the way," added the gentleman, "don't be too upset if I protest a bit when you come to shake me. I'm a heavy sleeper and take a while to wake up properly. Just put me out on the platform, even if I have a bit of a temper."

In the morning he awoke and discovered that the train was long past Whitland, and indeed was just arriving in Milford Haven. He was furious, and after finding the guard he told him off in no uncertain fashion.

"Oh dear!" said the guard. "I thought you was in compartment

number five. I sees now that you do have a bit of a temper, sir, but it's nothin' compared to the temper of the gentleman I put out at Whitland!"

Avoiding Action

Eddie and Bert had just been finishing the harvest in a big field near Narberth, and were driving the combine harvester down a narrow lane on the way back to the farmyard. Suddenly an English holidaymaker came round the bend in a very fast Mercedes, and when confronted by the combine harvester filling the whole of the road he had to take drastic avoiding action. The car went up onto the hedge, did two somersaults in mid-air, and landed on its roof in the field. The tourist and his wife staggered out of the vehicle looking distinctly groggy.

Bert turned to Eddie and said "Good Lord! Did you see that?"

"Indeed I did," replied Eddie. "The Gods is with us today, that's for sure. We just got out of that field in time."

Roadside Incident

Billy Sprite was driving along the A40 towards Fishguard one night with a miserable wife alongside him and a back seat full of arguing children. He was overtaken by a panda car and forced to pull in to the side of the road. A policeman came up to the driver's window and said "Excuse me, sir, but do you realise that you are driving without a rear light on this car?"

Billy jumped out and examined the back end of the car. He groaned and fell to the ground in obvious distress, and was soon weeping floods of tears onto the policeman's boots.

"There, there," said the policeman. "Don't take it so hard, sir. I'm not going to do you for it, but I wanted to advise you to get your light fixed."

"Thank you very much, officer," said Billy when he had composed himself. "You are very kind. I suppose you haven't by any chance seen a caravan anywhere?"

Good Deed for the Day

Yamaha Jenkins was well known in Milford, where he used to roar up and down the main streets on his extremely large and noisy motor-bike. One day his friend Bert prevailed upon him to take him for a high-speed run. Yamaha agreed, but said to Bert: "Look pal, you haven't got the right

leathers for this sort of thing. At 100 mph half-way up Charles Street it gets a bit breezy. If I was you, pal, I'd put that overcoat on back to front so as to keep out the wind."

Bert did as he was told, and off they roared. Half-way along the street the bike hit a traffic calming bump, and Bert went flying off the back of the bike to end up in a crumpled heap in the middle of the road. Yamaha was horrified, and after turning the bike round he returned to the scene of the accident.

He pushed his way through the crowd of shoppers who had gathered round in order to help the casualty. "Is Bert all right?" he asked.

"Well," said a helpful gentleman, "he was until we turned his head round the right way."

Size isn't Everything

Samuel J Hamburger XV was a big and successful farmer from Texas who was on holiday in Pembrokeshire. He was driving around the Presely Hills area, and landed up near Crymych. He was checking out the quality of the local livestock, and happened upon on old farmer who was driving five cows back to his farm for the evening milking.

"Good day, sir," said Mr Hamburger. "Nice little Fresians you got there."

"Not bad indeed," replied Farmer Ifans. "I can tell you are not a local boy. From foreign parts is it? Doing a bit of far"Cattleman, myself," said the Texan. "Run a thousand head of purebreds on my spread. Not a bad place neither. Do you know, sir, that it takes me three days to drive right round it in my car?"

"Dammo, there's a pity for you," said the old farmer. "I understand the problem. You know, when I was young I used to have a car like that myself."

SUPERIOR INTELLECTS

A Complex Matter

Larry Legless and Sam Stout were well known in Haverfordwest for drinking rather more than was good for them. In fact, they had been drinking partners for more than thirty years. One evening, as they sat slumped in the corner of the Bumbles and Flies down by the Old Bridge, the following conversation was heard to pass between them. "Good evenin', sir!" said Larry. "Now then, have I not seen thee afore somewhere?"

"Wouldn't be surprised," replied Sam, "since I've been about a tidy bit over the years. Maybe we met up some time down in Tenby?"

"Couldn't have bin me. Never bin to Tenby in me life."

"Not me neither. But there's a funny thing for thee. The question is, who the hell was them two chaps that met up that time in Tenby?"

The Marloes Riddle

A Sociology professor from Oxford University was staying in Marloes while he researched the quaint ways of country folk. One evening he went into the village pub for a quiet pint, and got talking to a local farmhand called Davy Dawdle. "Very fond of riddles around here, we are," said Davy. "Is that so?' said the professor. "How very interesting. Tell you what, why don't you try some on me?"

"Oh all right," replied Davy. "And tha can try some on me too." Then the professor said "Just to make it more interesting, I'll pay you a pound every time I miss a riddle, and you can pay me a pound every time you miss one."

"But that ain't fair," said Davy. "Tha'art an educated man an' I don't know nothin'. It'll be fairer if I pays thee fifty pence and tha pays me a quid." The professor agreed, and after thinking for a while Davy came up with this riddle: "What has three legs walking, four legs swimming and one leg flying?"

The professor just couldn't work it out, and at last he said; "I have to admit that I am quite defeated. Here's a pound. Now then, what's the answer?"

"Well, there's a funny thing," said Davy. "I don't know the answer neither. Here's fifty pence change."

A Fair Exchange

Douglas Morris of Burton was one of Pembrokeshire's leading innovators in matters agricultural. One day he read that water buffalo were going to be the meat producers of the future -- easy to keep, very lean and very hardy in wet conditions. He bought a little water buffalo calf.

He fattened it up alongside a Hereford calf, but the latter put on weight at a far faster rate than the water buffalo and started to bully it mercilessly. Douglas did not know quite what to do, but then he had a bright idea.

In the next edition of the "Western Telegraph" the following advert appeared: "Wanted -- shorthand typist. Willing to exchange for one buffalo."

Every Kind of Sandwich

Dicky Jones the grocer had a little shop on the main street in Cardigan. Business was slack, so he decided that he had better change the image of the shop. Accordingly he transformed it into a delicatessen, thereby becoming known by the locals as Dicky Delicate. As part of his new marketing strategy he went into exotic sandwiches in a big way, and he put up a prominent sign in his window which read "We make every kind of sandwich in the world."

One of the locals came into the shop at lunchtime, and just for fun he asked for a whalemeat sandwich. The assistant was slightly taken aback, and said: "Hang on a minute if you please. I'd better check with the boss to see if whalemeat sandwiches are on or off today."

A minute later she came back into the shop. "Mr Jones is very sorry," she reported. "But he says he's damned if he is going to cut up a whole whale just for one sandwich."

That Fella from Newport

In the old days there was no love lost between the people of Newport and the people of Cardigan. A new sailing ship was launched on the Parrog, in the Nevern Estuary, and Captain Watkins signed up a crew of five for the maiden voyage to Bristol.

In the crew there was one man from Newport and another from Cardigan. Sadly, they did not get on at all well together. In the middle of the Bristol Channel the ship ran into a fearsome storm, and while the Newport man was making his way gingerly along the deck with a bucket of grease he was swept overboard by a huge wave and disappeared without trace.

The Cardigan sailor was not far away, and he observed what happened. About ten minutes later he made his way slowly up to the bridge, and said to the Captain Watkins: "Captain, there is something to report."

"Yes, Albert? What is it?"

"You know that fella from Newport?"

"Of course I do. What about him?"

"Well, he's just gone off with your bucket."

Acknowledgements

Since I embarked upon my series of five local joke books back in 1994 I have received a huge amount of assistance from Pembrokeshire people who have rung me up, sent me scraps of paper through the post, and accosted me in the street in order to pass on their favourite funny stories. Other jokes were sent in to the "Western Telegraph" in 1997 during the course of my "Cheer up Pembrokeshire" joke competition. Sadly, some of them are unprintable in a book intended for family use! Others are regurgitated versions of jokes which I have already used, or slight variations on a few standard joke themes. In the foregoing pages I have used as many of the submitted jokes as I could find space for, and I extend grateful thanks to all who have happily entered into the spirit of the enterprise. It is heartening to know that there are many Pembrokeshire people who want to ensure that we maintain the ability to laugh at ourselves!